Days

My Boyhood Days

Rabindranath Tagore

Rupa & Co

Concept and typeset copyright © Rupa & Co. 2005

Published 2005 by

Rupa . Co

7/16, Ansari Road, Daryaganj,
New Delhi 110 002

Sales Centres:

Allahabad Bangalore Chandigarh
Chennai Hyderabad Jaipur Kathmandu
Kolkata Mumbai Pune

Typeset by
Nikita Overseas Pvt Ltd.
1410 Chiranjiv Tower,
43 Nehru Place
New Delhi 110 019

Printed in India by
Gopsons Papers Ltd.
A-14 Sector 60
Noida 201 301

I

The Calcutta where I was born was an altogether old-world place. Hackney carriages lumbered about the city raising clouds of dust, and the whips fell on the backs of skinny horses whose bones showed plainly below their hide. There were no trams then, no buses, no motors. Business was not the breathless rush that it is now, and the days went by in leisurely fashion. Clerks would take a good pull at the hookah before starting for office, and chew their betel as they went along. Some rode in palanquins, others joined in groups of four or five to hire a carriage in common, which was known as a "share-carriage". Wealthy men had monograms painted on their carriages, and a leather hood over the rear portion, like a half-drawn veil. The coachman sat on the box with his turban stylishly tilted to one side, and two grooms rode behind, girdles of yaks' tails round their waists, startling the pedestrians from their path with their shouts of "Hey-yo!"

Women used to go about in the stifling darkness of closed palanquins; they shrank from the idea of riding in carriages, and even to use an umbrella in sun or rain was considered unwomanly. Any woman who was so bold as to wear the new-fangled bodice, or shoes on her feet, was scornfully nicknamed "memsahib", that is to say, one who had cast off all sense of propriety or shame. If any woman unexpectedly encountered a stange man, one outside her family circle, her veil would promptly descend to the very tip of her nose, and she would at once turn her back on him. The palanquins in which women went out were shut as closely as their apartments in the house. An additional covering, a kind of thick tilt, completely enveloped the palanquin of a rich man's daughters and daighters-in-law, so that it looked like a moving tomb. By its side went the durwan carrying his brass-bound stick. His work was to sit in the entrance and watch the house, to tend his beard, safely to conduct the money to the bank and the women to their relatives houses, and on festival days to dip the lady of the house into the Ganges, closed palanquin and all. Hawkers who came to the door with their array of wares would grease Shivnandan's palm to gain admission, and the drivers of hired carriages were also a source of profit to him. Sometimes a man who was unwilling to fall in with this idea of going shares would create a great scene in front of the porch.

Our "jamadar" Sobha Ram, who was a wrestler, used to spend a good deal of time in practising his preaparatory feints and approaches, and in brandishing his heavy clubs. Sometimes he would sit and grind hemp for drink, and sometimes he would be quietly eating his raw radishes, tender leaves and all, when we boys would creep upon him and yell "Radhakrishna!" in his ear. The more he waved his arms and protested the more we delighted in teasing him. And perhaps—who knows?—his protests were merely a cunning device for hearing repeated the name of his favourite god.

There was no gas then in the city, and no electric light. When the kerosene lamp was introduced, its brilliance amazed us. In the evening the house-servant lit castor-oil lamps in every room. The one in our study-room had two wicks in a glass bowl.

By this dim light my master taught me from Peary Sarkar's First Book. First I would begin to yawn, and then, growing more and more sleepy, rub my heavy eyes. At such times I heard over and over again of the virtues of my master's other pupil Satin, a paragon of a boy with a wonderful head for study, who would rub snuff in his eyes to keep himself awake, so earnest was he. But as for me—the less said about that the better! Even the awful thought that I should probably remain the only dunce in the family could not keep me awake. When nine o'clock struck I was released, my eyes dazed and my mind drugged with sleep.

There was a narrow passage, enclosed by latticed walls, leading from the outer apartments to the interior of the house. A dimly burning lantern swung from the ceiling. As I went along this passage, my mind would be haunted by the idea that something was creeping upon me from behind. Little shivers ran up and down my back. In those days devils and spirits lurked in the recesses of every man's mind, and the air was full of ghost stories. One day it would be some servant girl falling in a dead faint because she had heard the nasal whine of Shañk-chunni. The female demon of that name was the most bad-tempered devil of all, and was said to be very greedy of fish. Another story was connected with the thick-leaved *bādām* tree at the western corner of the house. A mysterious Shape was said to stand with one foot in its branches and the other on the third storey cornice of the house. Plenty of people declared that they had seen it, and there were not a few who believed them. A friend of my elder brother's laughingly made light of the story, and the servants looked upon him as lacking in all piety, and said that his neck would surely be wrung one day and his pretensions exposed. The very atmosphere was so enmeshed in ghostly terrors that I could not put my feet into the darkness under the table without them getting the creeps.

There were no water-pipes laid on in those days. In the spring months of *Māgh* and *Fālgoon* when the Ganges water was clear, our bearers would bring it

up in brimming pots carried in a yoke across their shoulders. In the dark rooms of the ground floor stood rows of huge water jars filled with the whole year's supply of drinking water. All those musty, dingy, twilit rooms were the home of furtive "Things"— which of us did not know all about those "Things"? Great gaping mouths they had, eyes in their breasts, and ears like winnowing fans; and their feet turned backwards. Small wonder that my heart would pound in my breast and my knees tremble when I went into the inner garden, with the vision of those devilish shapes before me.

At high tide the water of the Ganges would flow along a masonry channel at the side of the road. Since my grandfather's time an allowance of this water had been discharged into our tank. When the sluices were opened the water rushed in, gurgling and foaming like a waterfall. I used to watch it fascinated, holding on by the railings of the south verandah. But the days of our tank were numbered, and finally there came a day when cartload after cartload of rubbish was tipped into it. When the tank no longer reflected the garden, the last lingering illusion of rural life left it. That *bādām* tree is still standing near the third storey cornice, but though his footholds remain, the ghostly shape that once bestrode them has disappeared for ever.

II

The palanquin belonged to the days of my grandmother. It was of ample proportions and lordly appearance. It was big enough to have needed eight bearers for each pole. But when the former wealth and glory of the family had faded like the glowing clouds of sunset, the palanquin bearers, with their gold bracelets, their thick ear-rings, and their sleeveless red tunics, had disappeared along with it. The body of the palanquin had been decorated with coloured line drawings, some of which were now defaced. Its surface was stained and discoloured, and the coir stuffing was coming out of the upholstery. It lay in a corner of the counting-house verandah as though it were a piece of common-place lumber. I was seven or eight years old at that time.

I was not yet, therefore, of an age to put my hand to any serious work in the world, and the old palanquin on its part had been dismissed from all useful service. Perhaps it was this fellow-feeling that so much attracted

me towards it. It was to me an island in the midst of the ocean, and I on my holidays became Robinson Crusoe. There I sat within its closed doors, completely lost to view, delightfully safe from prying eyes.

Outside my retreat, our house was full of people, innumerable relatives and other folk. From all parts of the house I could hear the shouts of the various servants at their work. Pari the maid is returning from the bazaar through the front courtyard with her vegetables in a basket on her hip. Dukhon the bearer is carrying in Ganges water in a yoke across his shoulder. The weaver woman has gone into the inner apartments to trade the newest style of saries. Dinu the goldsmith, who receives a monthly wage, usually sits in the room next to the lane, blowing his bellows and carrying out the orders of the family; now he is coming to the counting house to present his bill to Kailash Mukherjee, who has a quill pen stuck over his ear. The carder sits in the courtyard cleaning the cotton mattress stuffing on his twanging bow. Mukundalal the durwan is rolling on the ground outside with the one-eyed wrestler, trying out a new wrestling fall. He slaps his thighs loudly, and repeats his "physical jerks" twenty or thirty times, dropping on all fours. There is a crowd of beggars sitting waiting for their regular dole.

The day wears on, the heat grows intense, the clock in the gate-house strikes the hour. But inside the palanquin the day does not acknowledge the authority of clocks. Our midday is that of former days, when

the drum at the great door of the king's palace would be beaten for the breaking-up of the court, and the king would go to bathe in sandal-scented water. At midday on holidays those in charge of me have their meal and go to sleep. I sit on alone. My palanquin, outwardly at rest, travels on its imaginary journeys. My bearers, sprung from "airy nothing" at my bidding, eating the salt of my imagination, carry me wherever my fancy leads. We pass through far, strange lands, and I give each country a name from the books I have read. My imagination has cut a road through a deep forest. Tigers' eyes blaze from the thickets, my flesh creeps and tingles. With me is Biswanath the hunter; his gun speaks—Crack! Crack!—and there, all is still. Sometimes my palanquin becomes a peacock-boat, floating far out on the ocean till the shore is out of sight. The oars fall into the water with a gentle plash, the waves swing and swell around us. The sailors cry to us to beware, a storm is coming. By the tiller stands Abdul the sailor, with his pointed beard, shaven moustache and close-cropped head. I know him, he brings hilsa fish and turtle eggs from the Padma for my elder brother.

Abdul has a story for me. One day at the end of *Chaitra*[1] he had gone out in a dinghy to catch fish when suddenly there arose a great *Vaisākh* gale[2]. It

1. March-April.
2. Nor-wester, a very common phenomenon in Bengal in the beginning of the hot weather.

was a tremendous typhoon and the boat sank lower and lower. Abdul seized the tow-rope in his teeth, and jumping into the water swam to the shore, where he pulled his dinghy up after him by the rope. But the story comes to an end far too quickly for my taste, and besides, the boat is not lost, everything is saved—that isn't what I call a story! Again and again I demand, "What next?" "Well," says Abdul at last, "after that there were great doings. What should I see next but a panther with enormous whiskers. During the storm he had climbed up a *pākur* tree on the village ghat on the other side of the river. In the violent wind the tree broke and fell into the Padma. Brother Panther came floating down on the current, rolled over and over in the water and reached and climbed the bank on my side. As soon as I saw him I made a noose in my tow-rope. The wild beast drew near, his big eyes glaring. He had grown very hungry with swimming, and when he saw me saliva dribbled from his red, lolling tongue. But though he had known many other men, inside and out, he did not know Abdul. I shouted to him, "Come on old boy", and as soon as he raised his fore-feet for the attack I dropped my noose round his neck. The more he struggled to get free the tighter grew the noose, until his tongue began to loll out...." I am tremendously excited. "He didn't die, did he Abdul?" I ask. "Die?" says Abdul, "He couldn't die for the life of him! Well, the river was in spate, and I had to get back

to Bahadurganj. I yoked my young panther to the dinghy and made him tow me fully forty miles. Oh, he might roar and snarl, but I goaded him on with my oar, and he carried me a ten or fifteen hours' journey in an hour and a half! Now, my little fellow, don't ask me what happened next, for you won't get an answer."

"All right," say I, "so much for the panther; now for the crocodile?" Says Abdul, "I have often seen the tip of his nose above the water. And how wickedly he smiles as he lies basking in the sun, stretched at full length on the shelving sandbanks of the river. If I'd had a gun I should have made his acquaintance. But my license has expired...."

"Still, I can tell you one good yarn. One day Kanchi the gypsy woman was sitting on the bank of the river trimming bamboo with a bill-hook, with her young goat tethered near by. All at once the crocodile appeared on the surface, seized the billy-goat by the leg and dragged it into the water. With one jump the gypsy woman landed astride on its back, and began sawing with her sickle at the throat of the "demon-lizard", over and over again. The beast let go of the goat and plunged into the water...."

"And then? And then?" comes my excited question. "Why," says Abdul, "the rest of the story went down to the bottom of the river with the crocodile. It will take some time to get it up again. Before I see you

again I will send somebody to find out about it, and let you know." Abdul has never come again; perhaps he is still looking for news.

So much, then, for my travels in the palanquin. Outside the palanquin there were days when I assumed the role of teacher, and the railings of the verandah were my pupils. They were all afraid of me, and would cower before me in silence. Some of them were very naughty, and cared absolutely nothing for their books. I told them with dire threats that when they grew up they would be fit for nothing but casual labour. They bore the marks of my beatings from head to foot, yet they did not stop being naughty. For it would not have done for them to stop, it would have made an end of my game.

There was another game too, with my wooden lion. I heard stories of poojah sacrifices and decided that a lion sacrifice would be a magnificent thing. I rained blows on his back—with a frail little stick. There had to be a "mantra", of course, otherwise it would not have been a proper poojah:

"Liony, liony, off with your head,
　　Liony, liony, now you are dead.
　　Woofle the walnut goes clappety clap,
　　　　　　Snip, snop, SNAP!"

I had borrowed almost every word in this from other sources; only the word walnut was my own. I

was very fond of walnuts. From the words "clappety clap" you can see that my sacrificial knife was made of wood. And the word "snap" shows that it was not a strong one.

III

The clouds have had no rest since yesterday evening. The rain is pouring incessantly. The trees stand huddled together in a seemingly foolish manner; the birds are silent. I call to mind the evenings of my boyhood.

We used then to spend our evening in the servants' quarters. At that time English spellings and meanings did not yet lie like a nightmare on my shoulders. My third brother used to say that I ought first to get a good foundation of Bengali and only afterwards to go on to the English superstructure. Consequently, while other school-boys of my age were glibly reciting "I am up", "He is down", I had not even started on B, A, D, bad and M, A, D, mad.

In the speech of the nabobs the servants' quarters were then called "tosha-khana". Even though our house had fallen far below its former aristocratic state, these old high-sounding names, "tosha-khana", "daftar-khana", "baithak-khana", still clung to it.

On the southern side of this "tosha-khana", a castor oil lamp burned dimly on a glass stand in a big room; on the wall was a picture of Ganesh and a crude country painting of the goddess Kali, round which the wall lizards hunted their insect prey. There was no furniture in the room, merely a soiled mat spread on the floor.

You must understand that we lived like poor people, and were consequently saved the trouble of keeping a good stable. Away in a corner outside, in a thatched shed under a tamarind tree, was a shabby carriage and an old horse. We wore the very simplest and plainest clothes, and it was a long time before we even began to wear socks. It was luxury beyond our wildest dreams when our tiffin rations went beyond Brajeswar's inventory and included a loaf of bread, and butter wrapped in a banana leaf. We adapted ourselves easily to the broken wrecks of our former glory.

Brajeswar was the name of the servant who presided over our mat seat. His hair and beard were grizzled, the skin of his face dry and tight-drawn; he was a man of serious disposition, harsh voice, and deliberately mouthed speech. His former master had been a prosperous and well-known man, yet necessity had degraded him from that service to the work of looking after neglected children like us. I have heard that he used to be a master in a village school. To the end of his life he kept this school-masterly language and prim manner. Instead of saying "The gentlemen are

waiting", he would say "They await you", and his masters smiled when they heard him. He was as finicky about caste matters as he was conceited. When bathing he would go down into the tank and push back the oily surface water five or six times with his hands before taking a plunge. When he came out of the tank after his bath Brajeswar would edge his way through the garden in so gingerly a way that one would think he could only keep caste by avoiding all contact with this unclean world that God has made. He would talk very emphatically about what was right and what was wrong in manners and behaviour. And besides, he held his head a little on one side, which made his words all the more impressive.

But with all this there was one flaw in his character as *guru*. He cherished secretly a suppressed greed for food. It was not his method to place a proper portion of food on our plates before the meal. Instead, when we sat down to eat he would take one *luchi*[1] at a time, and dangling it at a little distance ask, "Do you want any more?" We knew by the tone of his voice what answer he desired, and I usually said that I didn't want any. After that he never gave us an opportunity to change our minds. The milk bowls also had an irresistible attraction for him—an attraction which I never felt at all. In his room was a small wired foodsafe with shelves in it. In it was a big brass bowl of milk,

1. Fried pancake known in Hindusthani as *puri*.

and *luchis* and vegetables on a wooden platter. Outside the wire-netting the cat prowled longingly to and fro sniffing the air.

From my childhood upwards these short commons suited me very well. Small rations cannot be said to have made me weak. I was, if anything, stronger, certainly not weaker, than boys who had unlimited food. My constitution was so abominably sound that even when the most urgent need arose for avoiding school, I could never make myself ill by fair means or foul. I would get wet through shoes, stockings and all, but I could not catch cold. I would lie on the open roof in the heavy autumn dew; my hair and clothes would be soaked, but I never had the slightest suspicion of a cough. And as for that sign of bad digestion known as stomachache, my stomach was a complete stranger to it, though my tongue made use of its name with mother in time of need. Mother would smile to herself and not feel the least anxiety; she would merely call the servant and tell him to go and tell my teacher that he should not teach me that evening. Our old-fashioned mothers used to think it no great harm if the boys occasionally took a holiday from study. If we had fallen into the hands of these present-day mothers, we should certainly have been sent to the teacher, and had our ears tweaked into the bargain. Perhaps with a knowing smile they would have dosed us with castor oil, and our pains would have been permanently cured. If by chance I got a slight temperature no one ever

called it fever, but "heated blood". I had never set eyes on a thermometer in those days. Dr. Nilmadhav would come and place his hand on my body, and then prescribe as the first day's treatment castor oil and fasting. I was allowed very little water to drink, and what I had was hot, with a few sugar-coated cardamoms for flavouring. After this fast, the *mouralā fish* soup and soft-boiled rice which I got on the third day seemed a veritable food for the gods.

Serious fever I do not remember, and I never heard the name of malaria. I do not remember quinine—that castor oil was my most distasteful medicine. I never knew the slightest scratch of a surgeon's knife; and to this very day I do not know what measles and chicken-pox are. In short, my body remained obstinately healthy. If mothers want their children to be so healthy that they will be unable to escape from the school master, I recommended them to find a servant like Brajeswar. He would save not only food bills but doctor's bills also, especially in these days of mill flour and adulterated ghee and oil. You must remember that in those days chocolate was still unknown in the bazaar. There was a kind of rose lollipop to be had for a pice. I do not know whether modern boy's pockets are still made sticky by this sesamum-covered sugar-lump, with its faint scent of roses. It has certainly fled in shame from the houses of the respectable people of to-day. What has become of those cone-shaped packets of fried spices? And

those cheap sesamum sweetmeats? Do they still linger on? If not, it is no good trying to bring them back.

Day after day, in the evenings, I listened to Brajeswar reciting the seven cantos of Krittibas' *Rāmayanā*. Kishori Chatterjee used to drop in sometimes while the reading was going on. He had by heart *Pānchāli*[2] versions of the whole *Rāmayanā*, tune and all. He took possession at once of the seat of authority, and superseding Krittibas, would begin to recite his simple folk-stanzas in great style:

"Lakshman O hear me
 Greatly I fear me
 Dangers are near me."

There was a smile on his lips, his bald head gleamed, the song poured from his throat in a torrent of sound, the rhymes jingled and rang verse after verse, like the music of pebbles in a brook. At the same time he would be using his hands and feet in acting out the thought. It was Kishori Chatterjee's greatest grief that Dadabhai, as he called me, could not join a troupe of strolling players and turn such a voice to account. If I did that, he said, I should certainly make my name.

By and by it would grow late and the assembly on the mat would break up. We would go into the house, to Mother's room, haunted and oppressed on our way

2. A kind of folk-version very popular in Bengal.

by the terror of devils. Mother would be playing cards with her aunt, the inlaid parquet floor gleamed like ivory, a coverlet was spread on the big divan. We would make such a disturbance that Mother would soon throw down her hand and say, "If they are going to be such a nuisance, auntie, you'd better go and tell them stories." We would wash our feet with water from the pot on the verandah outside, and climb on to the bed, pulling "Didima" with us. Then it would begin—stories of the magical awakening of the princess and her rescue from the demon city. The princess might wake, but who could waken me? ... In the early part of the night the jackals would begin to howl, for in those days they still haunted the basements of some of the old houses of Calcutta with their nightly wail.

IV

When I was a little boy Calcutta city was not so wakeful at night as it is now. Nowadays, as soon as the day of sunlight is over, the day of electric light begins. There is not much work done in it, but there is no rest, for the fire continues, as it were, to smoulder in the charcoal after the blazing wood has burnt itself out. The oil mills are still, the steamer sirens are silent, the labourers have left the factories, the buffaloes which pull the carts of jute bales are stabled in the tin-roofed sheds. But the nerves of the city are throbbing still with the fever of thought which has burned all day in her brain. Buying and selling go on as by day in the shops that line the streets, though the fire is a little choked with ash. Motors continue to run in all directions, emitting all kinds of raucous grunts and groans, though they no longer run with the zest of the morning. But in those old times which we knew, when the day was over whatever business remained undone wrapped itself up in the black blanket

of the night and went to sleep in the darkened ground-floor premises of the city. Outside the house the evening sky rose quiet and mysterious. It was so still that we could hear, even in our own street, the shouts of the grooms from the carriages of those people of fashion who were returning from taking the air in Eden Gardens by the side of the Ganges.

In the hot season of *Chaitra* and *Vaishākh* the hawkers would go about the streets shouting "I-i-i-ce". In a big pot full of lumps of ice and salt water were little tin containers of what we called "kulpi" ice—nowadays ousted by the more fashionable ices or "ice-cream". No one but myself knows how my mind thrilled to that cry as I stood on the verandah facing the street. Then there was another cry, "*Bela* flowers". Nowadays for some reason one hears little of the gardeners baskets of spring flowers—I do not know why. But in those days the air was full of the scent of the thickly strung *bel* flowers which the women and girls wore in their hairknots. Before they went to bathe the women would sit outside their rooms with a hand-mirror set up before them, and dress their hair. The knot would be skilfully bound with the black hair-braid into all sorts of different styles. They wore black-bordered Chandernagore saries, skilfully crinkled before use by pleating and twisting after the fashion of those days. The barber's wife would come to scrub their feet with pumice and paint them with red lac. She and her like were the gossipmongers of the women's courts.

The crowds returning from office or from college did not then, as they do now, rush to the football fields, clinging in swarms to the foot-boards of the trams. Nor did they crowd in front of cinema halls as they returned. There was some active interest shown in drama, but alas! I was only a child then.

Children of those times got no share in the pleasures of the grown-ups, even from a distance. If we were bold enough to go near, we should be told, "Off with you, go and play." But if we boys made the amount of noise appropriate for proper play, it would then be, "Be quiet, do." Not that the grownups themselves conducted their pleasures and conversation in silence, by any means; and now and again we would stand on the fringe of their far-flung jubilations, as though sprinkled by the spray of a waterfall. We would hang over the verandah on our side of the courtyard, staring across at the brilliantly lit reception-room on the other side. Big coaches would roll up to the portico one after another. Some of our elder brothers conducted the guests upstairs from the front door, sprinkling them with rose-water from the sprinkler, and giving each one a small buttonhole or nosegay of flowers. As the dramatic entertainment proceeded, we could hear the sobs of the "highcaste *kulin* heroine", but we could make out nothing of their meaning, and our longing to know grew intense. We discovered later that though the sobber was certainly highcaste, "she" was merely our own brother-in-law. But in those

days grown-ups and children were kept apart as strictly as men and women with their separate apartments. The singing and dancing would go on in the blaze of the drawing-room chandeliers, the men would pull at the hookah, the women of the family would take their betel boxes and sit in the subdued light behind their screen, the visiting ladies would gather in these retired nooks, and there would be much whispering of intimate domestic gossip. But we children were in bed by this time, and lay listening as our maid-servants Piyari or Sankari told us stories—"In the moonlight, expanding like an opening flower..."

V

A little before our day it was the fashion among wealthy householders to run *jātrās* or troupes of actors. There was a great demand for boys with shrill voices to join these troupes. One of my uncles was patron of such an amateur company. He had a gift for writing plays, and was very enthusiastic about training the boys. All over Bengal professional companies were the rage, just as the amateur companies were in aristocratic circles. Troupes of players sprang up like mushrooms on all sides, under the leadership of some well-known actor or other. Not that either patron or manager was necessarily of high family or good education. Their fame rested on their own merits. *Jātrā* performances used to take place in our house from time to time. But we children had no part in them, and I managed to see only the preliminaries. The verandah would be full of members of the company, the air full of tobacco smoke. There were the boys, long-haired, with dark rings of weariness

under their eyes, and, young as they were, with the faces of grown men. Their lips were stained black with constant betel chewing. Their costumes and other paraphernalia were in painted tin boxes. The entrance door was open, people swarmed like ants into the courtyard, which, filled to the brim with the seething, buzzing mass, spilled over into the lane and beyond into the Chitpore Road. Then nine o'clock would strike, and Shyam would swoop down on me like a hawk on a dove, grip my elbow with his rough, gnarled hand, and tell me that Mother was calling me to go to bed. I would hang my head in confusion at being thus publicly dragged away, but would bow to superior force and go to my bedroom. Outside all was tumult and shouting, outside flared the lighted chandeliers, but in my room there was not a sound and a brass lamp burned low on its stand. Even in sleep I was dimly conscious of the crash of the cymbals marking the rhythm of the dance.

The grown-ups usually forbade everything on principle, but on one occasion for some reason or other they decided to be indulgent, and the order went forth that the children also might come to the play. It was a drama about Nala and Damayanti. Before it began we were sent to bed till half-past eleven. We were assured again and again that when the time came we should be roused, but we knew the ways of the grown-ups, and we had no faith at all in these promises—*they* were adults, and *we* were children!

That night, however, I did drag my unwilling body to bed. For one thing, Mother promised that she herself would come and wake me. For another thing, I always had to pinch myself to keep myself awake after nine o'clock. When the time came I was awakened and brought outside, blinking and bewildered in the dazzling glare. Light streamed brightly from coloured chandeliers on the first and second storeys, and the white sheets spread in the courtyard made it seem much bigger than usual. On one side were seated the people of importance, senior members of the family, and their invited guests. The remaining space was filled with a motley crowed of all who cared to come. The performing company was led by a famous actor wearing a gold chain across his stomach, and old and young crowded together in the audience. The majority of the audience were what the respectable would call "riff-raff". The play itself had been written by men whose hands were trained only to the villager's reed pen, and who had never practised on the letters of an English copy book. Tunes, dances, and story had all sprung from the very heart of rural Bengal, and no pundit had polished their style.

We went and sat by our elder brothers in the audience, and they tied up small sums of money in kerchiefs and gave them to us. It was the custom to throw this money on to the stage at the points where applause was most deserved. By this means the actors

gained some extra profit and the family a good reputation.

The night came to an end, but the play would not. I never knew whose arms gathered up my limp body, nor where they carried me. I was far too much ashamed to try to find out. I, a fellow who had been sitting like an equal among the grown-ups and doling out *baksheesh,* to be disgraced in this way before a whole courtyard full of people! When I woke up I was lying on the divan in my mother's room; it was very late, and already blazing hot. The sun had risen, but I had not risen!—Such a thing had never happened before.

Nowadays the city's pleasures flow on in an unbroken stream. There is always a cinema show somewhere, and whoever pleases may see it for a trifling sum. But in those days entertainments were few and far between, like water holes dug in the sandy bed of a dried up river, three or four miles apart. Like these too they lasted only a few hours, and the wayfarers hastily gathered round, drinking from their cupped hands to quench their thirst.

The old days were like a king's son who, from time to time on festive occasions, or according to his whim, distributes rich and royal gifts to all within his jurisdiction. Modern days are like a merchant's son, sitting at the cross-roads on some great highway with many kinds of cheap and tawdry goods spread glittering before him, and drawing his customers by highway and byway from every side.

VI

Brajeswar was the head-servant, and his second-in-command was called Shyam. He came from Jessore, and he was a real countryman, speaking in a dialect strange to Calcutta. He would say "tenārā" and "onārā" for "tārā" and "orā", "jāti" and "khāti" for "jete" and "khete". He used to call us affectionately "Domani". He had a dark skin, big eyes, long hair glistening with oil, and a strong, well-built body. He was really good at heart, and affectionate and kind to children. He used to tell us stories of dacoits. Dacoity stories filled men's houses then as universally as the fear of ghosts filled their minds. Even today dacoity is not uncommon; murder, assault and looting still take place, and the police still do not catch the right man. But nowadays this is only a news-item, it has none of the fascination of romance. In those days dacoities were woven into stories, and passed from mouth to mouth for long periods. In my childhood men were still to be met with who in their prime had

been members of dacoit gangs. They were all past-masters in the science of the *lathi,* and were surrounded by disciples eager to learn the art of single-stick. Men salaamed at the very mention of their names. Dacoity then was usually not a mere matter of rash, headstrong bloodshed. As bodily strength and skill played their part, so did a generous, gallant mind. Moreover, gentlemen's houses often contained an exercise-ground for the practice of *lathi*-fighting, and those who made a name on these grounds were acknowledged as masters even by dacoits, who gave them a wide berth. Many zemindars made a profession of dacoity. There was a story of a man of this class who had stationed his desperadoes at the mouth of a river. It was new moon, and poojah night, and when they returned, carrying a severed head to the temple in honour of Kali Kankali[1], the zemindar clapped his hands to his head and cried out, "What have you done? It's my son-in-law!"

We heard also about the exploits of the dacoits Raghu and Bishu. They used to give notice before they attacked, and there was nothing underhand in their dacoity. When their rallying-cry was heard in the distane, the blood of the villagers ran cold. But their code forbade them to lay hands on women. On one occasion, in fact, a woman even succeeded in "robbing the robbers", by appearing to them dressed as Kali,

1. The destructive aspect of the goddess Kali, pictured with a necklace of skulls.

brandishing the goddess's heavy curved blade, and claiming their devout offerings.

One day there was a display of dacoits' wrestling feats in our house. They were all strong young fellows, big-made, dark-skinned, and long-haired. One man tied a cloth round a heavy grain-pounder, seized the cloth in his teeth, and then flung the pounder upwards and backwards over his shoulder. Another got a man to grasp him by his shaggy hair, and then whirled him round and round by a mere turn of his head. Using a long pole as support and lever, they leaped up to the second storey. Then one man stood with his hands clasped above his bent head, and others shot through the aperture like diving birds. They also showed how it was possible for them to manage a dacoity twenty or thirty miles away, and the same night be found sleeping peacefully in their beds like law-abiding citizens. They had a pair of very long poles with a piece of wood lashed cross-wise in the middle of each as a foot-rest. These poles were called *rang-pā* (stilts). When walking with the tops of the poles held in the hands, and the feet on these footholds, one stride had the value of ten ordinary steps, and a man could run faster than a horse. I used to encourage boys at Santiniketan to practise stilt-walking—though without any idea of committing dacoity! My imagination mingled such pictures of dacoity feats with Shyam's stories with gruesome effect, so that I have often spent the evening with my arms huddled against my pounding heart!

Sunday was a holiday. On the previous evening the crickets were chirping in the thickets outside in the south garden, and the story was about Raghu the highwayman. My heart went pit-a-pit in the dim light and flickering shadows of the room. The next day in my holiday leisure I climbed into the palanquin. It began to move unbidden, its destination unknown, and my mind, enthralled still by the magic of the previous night's romance, knew a thrill of delicious fear. In the silent darkness my pulses attuned themselves to the rhythmic shouts of the bearers, and my body grew numb with terrified anticipation.

On the boundless expanse of plain the air quivers in the heat, in the distance glistens the Kali tank; the sand sparkles, the wide-spreading *pākur* tree leans from the bank of the river over the cracked, ruined *ghāt*. My romance-fed terrors are concentrated on that thick clump of reeds, and in the shade of the tree on that unknown plain. Nearer and nearer we approach, quicker and quicker beats my heart. Above the reeds can be seen the tips of one or two stout bamboo staves. The bearers will stop there to change shoulders. They will drink, and wind wet towels round their heads. And then?...

Then with a blood-curdling shout, the dacoits are upon us....

VII

From morning till night the mills of learning went on grinding. To wind up this creaking machinery was the work of *Shejadādā*[1], Hemendranath. He was a stern taskmaster, but it is useless now to try to hide the fact that the greater part of the cargo with which he sought to load our minds was tipped out of the boat and sent to the bottom. My learning at any rate was a profitless cargo. If one seeks to key an instrument to too high a pitch, the strings will snap beneath the strain.

Shejadādā made all arrangements for the education of his eldest daughter. When the time came he got her admitted into the Loreto Convent School, but even before that she had been given a foundation in Bengali. He also gave Protibha a thorough training in western music, which, however, did not cause her to lose her skill in Indian music. Among the gentlemen's families of that time she had no equal in Hindustani songs.

1. Third elder brother.

It is one merit of western music that its scales and exercises demand diligent practice, that it makes for a sensitive ear, and that the discipline of the piano allows of no slackness in the matter of rhythm.

Meanwhile she had learnt Indian music from her earliest years from our teacher Vishnu. In this school of music I also had to be entered. No present-day musician, whether famous or obscure, would have consented to touch the kind of songs with which Vishnu initiated us. They were the very commonest kind of Bengali folk songs. Let me give you a few examples:

"A gypsy lass is come to town
 To paint tattoos, my sister.
 The painting's nothing, so they tell,
 Yet she on me has cast a spell,
 And makes me weep and mocks me well,
 By her tattoos, my sister."

I remember also a few fragmentary lines, such as:

"The sun and moon have owned defeat,
 the firefly's lamp lights up the stage;
 the Moghul and the Pathan flag,
 the weaver reads the Persian page."

and:

"Your daugher-in-law is the plantain tree,
 Mother of Ganesh, let her be.

For if but one flower should blossom and grow
She will have so many children you won't
know what to do."

Lines too come back to me in which one can catch
a glimpse of old forgotten histories:

"There was a jungle of thorn and burr,
 Fit for the dogs alone;
 There did he cut for himself a throne..."

The modern custom is first to practise scales—*sā-re-ga-ma*, etc., on the harmonium, and then to teach some simple Hindu songs. But the wise supervisor who was then in charge of our studies understood that boyhood has its own childish needs, and that these simple Bengali words would come much more easily to Bengali children than Hindi speech. Besides this, the rhythm of this folk music defied all accompaniment by *tabla*. It danced itself into our very pulses. The experiment thus made showed that just as a child learns his first enjoyment of literature from his mother's nursery rhymes, he learns his first enjoyment of music also from the same source.

The harmonium, that bane of Indian music, was not then in vogue. I practised my songs with my *tamburā* resting on my shoulder, I did not subject myself to the slavery of the keyboard.

It was no one's fault but my own, that nothing could keep me for many days together in the beaten

track of learning. I strayed at will, filling my wallet with whatever gleanings of knowledge I chanced upon. If I had been disposed to give my mind to my studies, the musicians of these days would have had no cause to slight my work. For I had plenty of opportunity. As long as my brother was in charge of my education, I repeated Brahmo songs with Vishnu in an absentminded fashion. When I felt so inclined I would sometimes hang about the doorway while *Shejadādā* was practising, and pick up the song that was going on. Once he was singing to the *Behāg* air, "O thou of slow and stately tread". Unobserved I listened and fixed the tune in my mind, and astounded my mother— an easy task—by singing it to her that evening. Our family friend Srikantha Babu was absorbed in music day and night. He would sit on the verandah, rubbing *chāmeli* oil on his body before his bath, his *hookāh* in his hand, and the fragrance of amber-scented tobacco rising into the air. He was always humming tunes, which attracted us boys around him. He never *taught* us songs, he simply sang them to us, and we picked them up almost without knowing it. When he could no longer restrain his enthusiasm, he would stand up and dance, accompanying himself on the *sitār*. His big expressive eyes shone with enjoyment, he burst into the song, *Mai chhōrō brajaki bāsari,* and would not rest content till I joined in too.

In matters of hospitality, people kept open house in those days. There was no need for a man to be

intimately known before he was received. There was a bed to be had at any time, and a plate of rice at the regular meal times for any who chanced to come. One day, for example, one such stranger guest, who carried his *tamburā* wrapped in a quilt on his shoulder, opened his bundle, sat down, and stretched his legs at ease on one side of our reception room, and Kanai the *hookāh*-tender offered him the customary courtesy of the *hookāh*.

Pān, like tobacco, played a great part in the reception of guests. In those days the morning occupation of the women in the inner apartments consisted in preparing piles of *pān* for the use of those who visited the outer reception room. Deftly they placed the lime on the leaf, smeared catechu on it with a small stick, and putting in the appropriate amount of spice folded and secured it with a clove. This prepared *pān* was then piled into a brass container, and a moist piece of cloth, stained with catechu, acted as cover. Meanwhile, in the room under the staircase outside, the stir and bustle of preparing tobacco would be going on. In a big earthenware tub were balls of charcoal covered with ash, the pipes of the *hookāhs* hung down like snakes of *Nāgaloka,* with the scent of rosewater in their veins. This amber scent of tobacco was the first welcome extended by the household to those who climbed the steps to visit the house. Such was the invariable custom then prescribed for the fitting reception of guests. That overflowing bowl of

pān has long since been discarded, and the caste of *hookāh*-tenders have thrown off their liveries and taken to the sweetmeat shops, where they knead up three-day-old *sandesh* and refashion it for sale.

That unknown musician stayed for a few days, just as he chose. No one asked him any questions. At dawn I used to drag him from his mosquito curtains and make him sing to me. (Those who have no fancy for regular study revel in study that is irregular). The morning melody of *Bansi hāmāri re ...* would rise on the air.

After this, when I was a little older, a very great musician called Jadu Bhatta came and stayed in the house. He made one big mistake in being determined to teach me music, and consequently no teaching took place. Nevertheless, I did casually pick up from him a certain amount of stolen knowledge. I was very fond of the song *Ruma jhuma barakhā āju bādara¯ā ...* which was set to a *Kāfi* tune, and which remains to this day in my store of rainy season songs. But unfortunately just at this time another guest arrived without warning, who had a name as a tiger-killer. A Bengali tiger-killer was a real marvel in those days, and it followed that I remained captivated in his room for the greater part of the time. I realise clearly now what I never dreamed of then, that the tiger whose fell clutches he so thrillingly described could never have bitten him at all; perhaps he got the idea from the snarling jaws of the stuffed Museum tigers. But

in those days I busied myself eagerly in the liberal provision of *pān* and tobacco for this hero, while the distant strains of *kānārā* music fell faintly on my indifferent ears.

So much for music. In other studies the foundation provided by *Shejadādā* was equally generously laid. It was the fault of my own nature that no great matter came of it. It was with people like me in view that Ramprosad Sen wrote, "O Mind, you do not understand the art of cultivation." With me, the work of cultivation never took place. But let me tell you of a few fields where the ploughing at least was done.

I got up while it was still dark and practised wrestling—on cold days I shivered and trembled with cold. In the city was a celebrated one-eyed wrestler, who gave me practice. On the north side of the outer room was an open space known as the "granary". The name clearly had survived from a time when the city had not yet completely crushed out all rural life, and a few open spaces still remained. When the life of the city was still young our granary had been filled with the whole year's store of grain, and the *ryots* who held their land on lease from us brought to it their appointed portion. It was here that the lean-to shed for wrestling was built against the compound wall. The ground had been prepared by digging and loosening the earth to a depth of about a cubit and pouring over it a maund of mustard oil. It was mere child's play for the wrestler to try a fall with me there, but I would manage to get

well smeared with dust by the end of the lesson, when I put on my shirt and went indoors.

Mother did not like to see me come in every morning so covered with dust—she feared that the colour of her son's skin would be darkened and spoiled. As a result, she occupied herself on holidays in scrubbing me. (Fashionable housewives of today buy their toilet preparations in boxes from western shops; but then they used to make their unguent with their own hands. It contained almond paste, thickened cream, the rind of oranges and many other things which I forget. If only I had learnt and remembered the receipt, I might have set up a shop and sold it as "Begum Bilash" unguent, and made at least as much money as the *sandesh-wāllāhs*.) On Sunday mornings there was a great rubbing and scrubbing on the verandah, and I would begin to grow restless to get away. Incidentally a story used to go about among our school fellows that in our house babies were bathed in wine as soon as they were born, and that was the reason for our fair European complexions.

When I came in from the wrestling ground I saw a Medical College student waiting to teach me the lore of bones. A whole skeleton hung on the wall. It used to hang at night on the wall of our bedroom, and the bones swayed in the wind and rattled together. But the fear I might otherwise have felt had been overcome by constantly handling it, and by learning by heart the long, difficult names of the bones.

The clock in the porch struck seven. Master Nilkamal was a stickler for punctuality, there was no chance of a moment's variation. He had a thin, shrunken body, but his health was as good as his pupil's, and never once, unluckily for us, was he afflicted even by a headache. Taking my book and slate I sat down before the table, and he began to write figures on the blackboard in chalk. Everything was in Bengali, arithmetic, algebra and geometry. In literature I jumped at one bound from *Sitār Banabās*[2] to *Meghnādbadh Kābya*[3]. Along with this there was natural science. From time to time Sitanath Datta would come, and we acquired some superficial knowledge of science by experiments with familiar things. Once Heramba Tattvaratna, the Sanskrit scholar, came; and I began to learn the Mugdhabodh Sanskrit grammar by heart, though without understanding a word of it.

In this way, all through the morning, studies of all kinds were heaped upon me, but as the burden grew greater, my mind contrived to get rid of fragments of it; making a hole in the enveloping net, my parrot-learning slipped through its meshes and escaped—and the opinion that Master Nilkamal expressed of his pupil's intelligence was not of the kind to be made public.

2. "Sita in the Forest," by Iswarchandra Vidyasagar.
3. An Epic on the death of Meghnād (son of Rāvana in *Rāmāyana*) by Michael Madhusudan Dutta.

In another part of the verandah is the old tailor, his thick-lensed spectacles on his nose, sitting bent over his sewing, and ever and anon, at the prescribed hours, going through the ritual of his Namāz[4]. I watch him and think what a lucky fellow Niāmat is. Then, with my head in a whirl from doing sums, I shade my eyes with my slate, and looking down see in front of the entrance porch Chandrabhān the *durwan* combing his long beard with a wooden comb, dividing it in two and looping it round each ear. The assistant *durwan*, a slender boy, is sitting near by, a bracelet on his arm, and cutting tobacco. Over there the horse has already finished his morning allowance of gram, and the crows are hopping round pecking at the scattered grains. Our dog Johnny's sense of duty is aroused and he drives them away barking.

I had planted a custard-apple seed in the dust which continual sweeping had collected in one corner of the verandah. All agog with excitement, I watched for the sprouting of the new leaves. As soon as Master Nilkamal had gone, I had to run and examine it, and water it. In the end my hopes went unfulfilled—the same broom that had gathered the dust together dispersed it again to the four winds.

Now the sun climbs higher, and the slanting shadows cover only half the courtyard. The clock strikes nine. Govinda, short and dark, with a dirty

4. Muslim devotional exercises.

yellow towel slung over his shoulder, takes me off to bathe me. Promptly at half past nine comes our monotonous, unvarying meal—the daily ration of rice, *dāl* and fish curry—it was not much to my taste.

The clock strikes ten. From the main street is heard the hawker's cry of "Green Mangoes"—what wistful dreams it awakens! From further and further away resounds the clanging of the receding brass-peddler, striking his wares till they ring again. The lady of the neighbouring house in the lane is drying her hair on the roof, and her two little girls are playing with shells. They have plenty of leisure, for in those days girls were not obliged to go to school, and I used to think how fine it would have been to be born a girl. But as it is, the old horse draws me in the rickety carriage to my Andamans, in which from ten to four I am doomed to exile.

At half past four I return from school. The gymnastic master has come, and for about an hour I exercise my body on the parallel bars. He has no sooner gone than the drawing master arrives.

Gradually the rusty light of day fades away. The many blurred noises of the evening are heard as a dreamy hum resounding over the demon city of brick and mortar. In the study room an oil lamp is burning. Master Aghor has come and the English lesson begins. The black-covered reader is lying in wait for me on the table. The cover is loose; the pages are stained and a little torn; I have tried my hand at writing my name

in English in it, in the wrong places, and all in capital letters. As I read I nod, then jerk myself awake again with a start, but miss far more than I read. When finally I tumble into bed I have at last a little time to call my own. And there I listen to endless stories of the king's son travelling over an endless, trackless plain.

VIII

When I see the roofs of modern houses, uninhabited by either men or ghosts, I realise vividly the change that has taken place between those times and these. I have already mentioned how the *brahma-daitya*[1] of the *bādām* tree has fled, unable to endure the modern atmosphere of excessive learning. On the cornice where rumour had it that he had rested his foot, the crows snatch and squabble over our discarded mango stones. And men too restrict themselves nowadays to the confined, boxed-in rooms of the lower storeys, and pass their time within four walls.

My mind goes back to the parapet-surrounded roof of the inner apartments. It is evening, and Mother has spread her mat and seated herself, with her friends gossiping round her. Their talk has no need of authentic

1. A class of formidable ghosts believed to be the spirits of departed Brahmins.

information, it is only a means of passing the time. There was then no regular supply of valuable and varied ingredients to fill the day, which was not, as now, a closely woven mesh, but like a net of loose texture, full of holes. And therefore, stories and rumours, laughter and jokes, all in the lightest vein, filled both the social gatherings of the men and the women's assemblies. Among Mother's friends the first in importance was Braja Acharji's sister, who was called "Acharjini". She was the daily purveyor of news to the company. Almost every day she picked up, (or made up!) and brought with her, every item of fantastic, ominous news in the country. By this means expenditure on all ceremonies calculated to avert impending calamity or the evil eye, was greatly increased.

Into this assembly I imported from time to time my recently acquired book-learning. I informed them that the sun is nine crores of miles distant from the earth. From the second part of my *Rju-Path* I recited a portion of Valmiki's *Rāmāyana* in the original complete with Sanskrit terminations. Mother was no judge of the accuracy of her son's pronunciation, but the range of his learning filled her with awe, and seemed to her far to outrun the nine-crore miles journey of light. Who would have thought that any except Naradmuni himself could recite all these *slōkas?*

This inner apartment roof was entirely the women's domain, and had a close conection with the store room. The sun's rays fell full upon it, so it was used

for preparing lemons for pickle. The women used to sit there with brass vessels full of *kalāi* paste, and while their hair was drying they made pulse-balls with their deft, quick fingers. The maid-servants who had washed the soiled linen came here to spread it in the sun, for the *dhoby* had little work in those days. Green mangoes were cut in slices and dried into *āmsi*. The mango juice was poured layer after layer into black stone moulds of all sizes and all patterns[2]. A pickle of young jack-fruit stood there to season in sun-warmed mustard oil. Catechu, scented with the fragrant screw-pine, would be prepared with great care.

I had a special reason for remembering this item. When my school-master informed me that he had heard the fame of my family's screw-pine catechu, it was not difficult to understand his meaning. What he had heard of, he wished to become acquainted with. So to preserve the good name of my family, I occasionally climbed secretly to the roof containing the screw-pine catechu, and—what shall I say? "Appropriated" a piece or two sounds better than "stole". For even kings and emperors may make "appropriations" when need arises, or indeed even if it does not, but vulgar "stealing" is punished by prison or impaling.

In the pleasant sunlight of the cold weather it was the family tradition for the women to sit on the roof

2. This preparation is called *āmsatta*.

gossiping, driving off crows and passing the time of day. I was the only younger brother-in-law in the house, the guardian of my sister-in-law's "*āmsatta*", and her friend and ally in many other trival pursuits. I used to read to them from *Bangādhipa Parājaya*[3]. From time to time the duty of cutting up betel-nut would devolve on me. I could cut betel very finely. My sister-in-law would never admit that I had any other good quality, so much so that she even made me angry with God for giving me such a faulty appearance. But she found no difficulty in speaking in exaggerated fashion of my skill in cutting betel. Therefore the work of betel-cutting used to go on at a fine pace. But for a long time now, for want of anyone to encourage me, the hand that was so killed in fine betel-cutting has perforce busied itself in other fine work.

Around all this women's work spread on the roof there lingered the aroma of village life. These occupations belonged to the days when there was a pounding-room in the house, when confectionery balls were made, when the maid-servants sat in the evening rolling on their thighs the cotton wicks for the oil lamps, when invitations came from neighbours' houses to the ceremonies of the eighth day after birth. Modern children do not hear fairy stories from their mothers' lips, they read them for themselves in printed books.

3. "The Defeat of the King of Bengal."

Pickles and chutney are bought from the Newmarket by the bottleful, each bottle corked and sealed with wax.

Another relic of a bygone village life was the *chandimandap,* the outer verandah where the school was held. Not only the boys of the house, but those of the neighbourhood, also, made there their first attempt to search letters on palm-leaves. I suppose that I too must have traced out my first laborious letters on that verandah, but I have no clear memory of the child I then was, who seems as far removed as the farthest planet of the solar system, and I possess no telescope which can bring him into view.

The first thing I remember about reading after this is the terrible story of Ṣanāmārka Muni's school, and of the *avatār* Narasiṃha tearing the bowels of Hiraṇyakaśipu; I think also that there was a lead-plate engraving of it in the same book—and I remember also reading a few *slōkas* of Chānakya.

My chief holiday resort was the unfenced roof of the outer apartments. From my earliest childhood till I was grown up, many varied days were spent on that roof in many moods and thoughts. When my father was at home his room was on the second floor. How often I watched him at a distance, from my hiding place at the head of the staircase. The sun had not yet risen, and he sat on the roof silent as an image of white stone, his hands folded in his lap. From time to time he would leave home for long periods in the

mountains, and then the journey to the roof held for
me the joy of a voyage through the seven seas. Sitting
on the familiar first floor verandah I had daily watched
through the railings the people going about the street.
But to climb to that roof was to be raised beyond the
swarming habitations of men. When I went on to the
roof my mind strode proudly over prostrate Calcutta
to where the last blue of the sky mingled with the last
green of the earth; my eye fell on the roofs of countless
houses, of all shapes and sizes, high and low, with the
shaggy tops of trees between.

I would go up secretly to this roof, usually at
midday. The midday hours have always held a
fascination for me. They are like the night of the
daytime, the time when the *Sannyāsi* spirit in every
boy makes him long to quit his familiar surroundings.
I put my hand through the shutter and drew the bolt
of the door. Right opposite the door was a sofa, and
I sat there in perfect bliss of solitude. The servants
who acted as my warders had eaten their fill and
become drowsy, and yawning and stretching had
betaken themselves to sleep on their mats. The
afternoon sunlight deepened into gold, and the kite
rose screaming into the sky. The bangle-seller went
crying his wares down the opposite lane. His sudden
cry would penetrate to where the housewife lay with
her loosened hair falling over her pillow, a maidservant
would bring him in, and the old bangle-seller
dexterously kneaded the tender fingers as he fitted on

the glass bangles that took her fancy. The hushed
pause of that old-world midday is now no more, and
the hawkers of the silent time are heard no longer.
The girl who in those days had married status,
nowadays has still not attained it, she is learning her
lessons in the second class. Perhaps the bangle-seller
runs, pulling a rickshaw, down that very lane.

The roof was like what I imagined the deserts of
my books to be, a sheer expanse of quivering haze.
A hot wind ran panting across it, whirling up the dust,
the blue of the sky paled above it. Moreover, in this
roof desert there appeared an oasis. Nowadays the
pipe water does not reach the upper floors, but then
it ran even up to the second floor rooms. Like some
young Livingstone of Bengal, alone and unaided, I
secretly sought and found a new Niagara, the private
bathroom. I would turn on the tap, and the water
would run all over my body. I then took a sheet from
the bed and dried myself, looking the picture of
innocence.

Gradually the holiday drew towards its close, and
four struck on the gateway clock. The face of the sky
on Sunday evenings was always very ill-favoured. There
fell across it the shadow of the coming Monday's
gaping jaws, already swallowing it in dark eclipse.
Below at last a search had been instituted for the boy
who had given his guards the slip, for now it was tiffin
time. This part of the day was a red-letter time for
Brajeswar. He was in charge of buying the tiffin. In

those days the shop-keepers did not make thirty or forty per cent profit on the price of *ghee,* and in odour and flavour the tiffin was still unpoisoned. When we were lucky enough to get them, we lost no time in eating up our *kochuri, singārā,* or even *ālur dom.* But when the time came round and Brajeswar, with his neck still further twisted, called to us, "Look *babu,* what I have brought you today", what was usually to be found in his cone of paper was merely a handful of fried groundnuts. It was not that I did not like this, but its attractiveness lay in its price. I never made the least objection, not even on the days when only sesamum *gojā* came out of the palm-leaf wrapper.

The light of day begins to grow murky. Once more with a gloomy spirit, I make the round of the roof. I gaze down at the scene below, where a procession of geese has climbed out of the tank. People have begun to come and go again on the steps of the *ghāt,* the shadow of the banyan tree lengthens across half the tank, the driver of a carriage and pair is yelling at the pedestrians in the street.

IX

In this way the days passed monotonously on. School grabbed the best part of the day, and only fragments of time in the morning and evening slipped through its clutching fingers. As soon as I entered the classroom, the benches and tables forced themselves rudely on my attention, elbowing and jostling their way into my mind. They were always the same—stiff, cramping, and dead. In the evening I went home, and the oil lamp in our study-room, like a stern signal, summoned me to the preparation of the next day's lessons. There is a kind of grass-hopper which takes the colour of the withered leaves among which it lurks unobserved. In like manner my spirit also shrank and faded among those faded, drab-coloured days.

Now and again there came to our courtyard a man with a dancing bear, or a snake charmer playing with his snakes. Now and again the visit of a juggler provided some little novelty. Today the drums of the juggler and snake-charmer no longer beat in our Chitpore

Road. From afar they have salaamed to the cinema, and fled before it from the city. Games were few and of very ordinary kinds. We had marbles, we had what is called "bat-ball," a very poor distant relation of cricket, and there were also top-spinning and kite-flying. All the games of the city children were of this same lazy kind. Football, with all its running and jumping about on a big field, was still in its overseas home. And so I was fenced in by the deadly sameness of the days, as though by an imprisoning hedge of lifeless, withered twigs.

In the midst of this monotony there played one day the flutes of festivity. A new bride came to the house, slender gold bracelets on her delicate brown hands. In the twinkling of an eye the cramping fence was broken, and a new being came into view from the magic land beyond the bounds of the familiar. I circled around her at a safe distance, but I did not dare to go near. She was enthroned at the centre of affection, and I was only a neglected, insignificant child.

The house was then divided into two suites of rooms. The men lived in the outer, and the women in the inner apartments. The ways of the nabobs obtained there still. I remember how my elder sister was walking on the roof with the new bride at her side, and they were exchanging intimacies freely. As soon as I tried to go near, however, I brought reprimand on my head, for these quarters were outside the boundaries laid down for boys. I saw myself

obliged to go back crest-fallen to my shabby retreat
of former days.

The monsoon rain, rushing down suddenly from
the distant mountains, undermines the ancient banks
in a moment, and that is what happened now. The
new mistress brought a new régime into the house.
The quarters of the bride were in the room adjoining
the roof of the inner suite. That roof was under her
complete control. It was there that the leaf-plates
were spread for the dolls' weddings. On such feast
days, boy as I was, I became the guest of honour. My
new sister-in-law could cook well, and enjoyed feeding
people, and I was always ready to satisfy this craving
for playing the hostess. As soon as I returned from
school some delicacy made with her own hands stood
ready for me. One day she gave me shrimp curry with
yesterday's soaked rice, and a dash of chillies for
flavouring, and I felt that I had nothing left to wish
for. Sometimes when she went to stay with relatives
and I did not see her slippers outside the door of her
room, I would go in a temper and steal some valuable
object from her room, and lay the foundation of a
quarrel. When she returned and missed it, I had only
to make such a remark as "Do you expect *me* to keep
an eye on your room when you go away? Am I a
watchman?" She would pretend to be angry and say,
"You have no need to keep an eye on the room. Watch
you own hands." Modern women will smile at the
nad'veté of their predecessors who knew how to

entertain only their own brothers-in-law, and I daresay they are right. People today are much more grown-up in every way than they were then. Then we were all children alike, both young and old.

X

And so began a new chapter of my lonely Bedouin life on the roof, and human company and friendship entered it. Across the roof kingdom a new wind blew, and a new season began there. My brother Jyotidada played a large part in this change. At that time my father finally left our home at Jorasanko. Jyotidada settled himself into that outside second-floor room, and I claimed a little corner of it for my own.

No *purdah* was observed in my sister-in-law's apartments. That will strike no one as strange today, but it then sounded an unimaginable depth of novelty. A long time even before that, when I was a baby, my second brother had returned from England to enter the Civil Service. When he went to Bombay to take up his first post he astonished the neighbourhood by taking off his wife with him before their very eyes. And as if it was not enough to take her away to a distant province, instead of leaving her in the family

home, he made no provision for proper privacy on the journey. That was a terrible breach of propriety. Even the relatives felt as if the sky had fallen on their heads.

A style of dress suitable for going out was still not in vogue among women. It was this sister-in-law who first introduced the manner of wearing the *sari* and blouse which is now customary. Little girls had not then begun to wear frocks or let their hair hang in plaits—at least not in our family. The little ones used to wear the tight Rajput pyjamas instead of the traditional *sari*. When the Bethune School was first opened my eldest sister was quite young. She was one of the pioneers who made the road to education easy for girls. She was very fair, uniquely so for this country. I have heard that once when she was going to school in her palanquin the police detained her, thinking her in her Rajput dress to be an English girl who had been kidnapped.

I said before that in those days there was no bridge of intimacy between adults and children. Into the tangle of these old customs Jyotidada brought a vigorously original mind. I was twelve years younger than he, and that I should come to his notice in spite of such a difference in age is in itself surprising. What was more surprising is that in my talks with him he never called me impudent or snubbed me. Thanks to this, I never lacked courage to think for myself. Today I live with children, I try all kind of subjects of

conversation, but I find them dumb. They hesitate to ask questions. They seem to me to belong to those old times when the grown-ups talked and the children remained silent. The self-confidence that doubts and questions is the mark of the children of the new age; those of the former age are known by a meek and docile acceptance of what they are told.

A piano appeared in the terrace room. There came also modern varnished furniture from Bowbazar. My breast swelled with pride, as the cheap grandeur of modern times was displayed before eyes inured to poverty. At this time the fountain of my song was unloosed. Jyotidada's hands would stray about the piano as he composed and rattled off tunes in various new styles, and he would keep me by his side as he did so. It was my work to fix the tunes which he composed so rapidly by setting words to them then and there.

At the end of the day a mat and pillow were spread on the terrace. Nearby was a thick garland of *bel* flowers on a silver plate, in a wet handkerchief, a glass of iced water on a saucer, and some *chhānchi pān* in a bowl. My sister-in-law would bathe, dress her hair and come and sit with us. Jyotidada would come out with a silk *chaddar* thrown over his shoulders, and draw the bow across his violin, and I would sing in my clear treble voice. For providence had not yet taken away the gift of voice it had given me, and under the sunset sky my song rang out across the house-tops.

The south wind came in great gusts from the distant sea, the sky filled with stars.

My sister-in-law turned the whole roof into a garden. She arranged rows of tall palms in barrels and beside and around them *chāmeli, gandharāj, rajanigandhā, karabi* and *dolan-champā*. She considered not at all the possible damage to the roof—we were all alike unpractical visionaries.

Akshay Chaudhuri used to come almost every day. He himself knew that he had no voice, other people knew it even better. In spite of that nothing could stop the flow of his song. His special favourite was the *Behāg* mode. He sang with his eyes shut, so he did not see the expression on the faces of his hearers. As soon as anything capable of making a noise came to hand, he took it and turned it into a drum, beating it in happy absorption, biting his lips with his teeth in his earnestness. Even a book with a stiff binding would do very well. He was by nature a dreamy kind of man, one could see no difference between his working days and his holidays.

The evening party broke up, but I was a boy of nocturnal habits. All went to lie down, I alone would wander about all night with the *Brahma-daitya*. The whole district was steeped in silence. On moonlight nights the shadows of the lines of palm-trees on the terrace lay in dream-patterns on the floor. Beyond the terrace the top of the *sishu* tree swayed and tossed in the breeze, and its leaves gleamed as they caught the

light. But for some reason, what caught my eye more than anything was a squat room with a sloping roof built over the staircase of the sleeping house on the opposite side of the lane. It stood like a finger pointing for ever towards I knew not what.

It may have been one or two in the morning, when in the main street in front a wailing chant arose—*Bolō-Hari Hari-bōl.*[1]

1. Funeral chant of the Hindus.

XI

It was the fashion then in every house to keep caged birds. I hated this, and the worst thing of all to me was the call of a *koel* imprisoned in a cage in some house in the neighbourhood. *Bouthākrun*[1] had acquired a Chinese *shyama*. From under its covering of cloth its sweet whistling rose continuously, a fountain of song. Besides this there were other birds of all kinds, and their cages hung in the west verandah. Every morning a bird-seed and insect hawker provided the birds' food. Grass-hoppers came from his basket, and gram-flour for the grain-eating birds.

Jyotidada gave me proper answers in my difficulties, but as much could not be expected from the women. Once *Bouthākrun* took a fancy for keeping pet squirrels in cages. I said it wasn't right, and she told me not to set myself up to be her teacher. That could hardly be called a reasoned reply, and

1. Sister-in-law.

consequently, instead of wasting time in bickering, I privately set two of the little creatures free. After that too I had to listen to a certain amount of scolding, but I made no retort.

There was a permanent quarrel between us which was never made up, which was as follows.

There was a smart fellow called Umesh. He used to go the rounds of the English tailoring shops and buy up for an old song all their scraps, remnants and strips of many coloured silk, and make up women's garments from them with the addition of a bit of net and cheap lace. He would open his paper parcel and spread them carefully out before the eyes of the women, extolling them as "the very latest fashion". The women could not resist the attraction of such a *mantra,* but I disliked it all intensely. Again and again, unable to contain myself, I made known my objections, but all the answer I got was "Don't be cheeky". I used to tell *Bouthākrun* that the old-fashioned black-bordered white saries, and the Dacca ones, were far better and more tasteful than these. I sometimes wonder, do modern brothers-in-law never open their mouths when they see their *Boudidis* robed in these modern georgette saries, with their faces painted like dolls? Even *Bouthākrun* decked out in Umesh's handiwork was not as bad as they are. Ladies then were at least not so guilty of forgery in dress or complexion.

I was however always beaten by *Bouthākrun* in argument, because she would never deign to give a

logical answer; and I was beaten too in chess, in which she was an expert.

As I have referred to Jyotidada I ought to give a little more information about him, to make him better known. To do that I must go back to rather earlier days.

He had to go very often to Shelidah to see after the business of the zemindari. Once when he was travelling for this purpose he took me also with him. This was quite contrary to custom in those days, in fact it was what people would have called "altogether *too* much". He certainly considered that this travelling away from home was a kind of peripatetic schooling. He realised that my nature was attuned to ramblings in the open air, that in such surroundings it nourished itself spontaneously. A little later, when I was more mature, it was in Shelidah that my nature developed.

The old indigo factory was still standing, with the river Padma in the distance. The zemindari office was on the ground floor, and our living quarters on the upper floor. In front of them was a very large terrace. Beyond were tall casuarina trees, which had grown in stature with the growing prosperity of the indigo-trading sahebs. Today the blustering shouts of the sahebs are completely silent. Where is now the indigo factory's steward, that "messenger of death"? Where the troop of bailiffs, loins girded up and *lāthis* on shoulder? Where is the dining hall with its long tables, where the sahebs rode back from their business in the

town and turned night into day? The feasting reached its height, the dancing couples whirled round the room, the blood coursed madly through the veins in the swelling intoxication of champagne—and the authorities never heard the appealing cries of the wretched *ryots,* whose weary journey took them only to the District Jail. All traces of those days have vanished, save one record alone—the two graves of two of the sahebs. The high casuarina trees bend and sway in the wind, and sometimes at midnight the grandsons and grand-daughters of the former *ryots* see the ghosts of the sahebs wandering in the deserted waste of garden.

Here I revelled in my solitude. I had a little corner room, and my days of ample leisure were spacious as the wide-spreading terrace. It was the leisure of a strange and unknown region, unfathomable as the dark waters of some ancient tank. The *bou-kathā-kao*[2] calls incessantly, my fancy unweariedly takes wing. Meantime my note-book is gradually filled with verses. They were like the blossoms of the mango-tree's first flowering in the month of *Māgh,* destined like them to wither forgotten.

In those days if a young boy, or still more a young girl, laboriously counted out the fourteen syllables and wrote two lines of verse, the wise critics of the

2. Also called "makwa-pāko", an Indian species of cuckoo. Both names are imitations of the call.

country used to hail it as a unique and unparalleled achievement.

I saw in the papers and magazines the names of these girl-poets, and their verses also were published. Nowadays these carefully constructed metres and crude rhyming platitudes have vanished along with the names of their authors, and the names of countless modern girls have appeared in their stead.

Boys are less bold and far more self-conscious than girls. I do not remember any young boy-poet writing verse in those days, except myself. My sister's son, who was older than I, explained to me one day that if one poured words into a fourteen-syllable mould, they would condense into verse. I soon tried this magic formula for myself. The lotus of poetry blossomed in no time in this fourteen-syllabled form and even the bees found a foothold on it. The gulf between me and the poets was bridged, and from that time on I have struggled to overtake them.

I remember how, when I was in the lowest class of the *chhātra britti*[3] our superintendent Govinda Babu heard a rumour that I wrote poetry. He thereupon ordered me to write, thinking that it would redound to the credit of the Normal School. There was nothing for it but to write, to read my work before my class-mates, and to hear the verdict—"this verse is assuredly

3. This corresponds roughly to the modern transition from "primary" to "secondary" education.

stolen goods". The cynics of that day did not know that when I increased in worldly wisdom I should grow shrewd in stealing, not words but thoughts. Yet it is these stolen goods which are valuable.

I remember once composing a poem in the *Payār* and *Tripadi* metres, in which I lamented that as one swims to pluck the lotus it floats further and further away on the waves raised by one's own arms, and remains always out of reach. Akshay Babu took me round to the houses of his relatives and made me recite it to them. "The boy has certainly a gift for writing", they said.

Bouthākrun's attitude was just the opposite. She would never admit that I should ever make a success of writing. She would say mockingly that I should never be able to write like Bihari Chakravarti. I used to think despondently that even if I were placed in a far lower class than he, she would then be prevented from so disregarding her little poet-brother-in-law's disapprobation of women's fashions.

Jyotidada was very fond of riding. He actually took even *Bouthākrun* riding along Chitpore Road to the Eden Gardens. In Shelidah he gave me a pony, a beast that was no mean runner. He sent me to give the pony a run on the open *rath-talā* field.[4] I did as I was bidden, in continual imminent danger of a fall

4. The field reserved in a Bengali village for the celebration of the car-festival.

on that uneven ground. That I did not fall was solely because he was so determined that I should *not* do so .Shortly afterwards Jyotidada sent me out riding on the roads of Calcutta also. Not on the pony, but on a high-spirited thoroughbred. One day it galloped straight in through the porch, with me on its back, to the courtyard where it was accustomed to be fed. From that day on I had nothing more to do with it.

I have referred elsewhere to the fact that Jyotidada was a practised shot. He was always eager for a tiger-hunt. One day the *shikāri* Visvanath brought news that a tiger was living in the Shelidah jungle, and Jyotidada at once furbished up his gun and prepared for sport. Surprising to say, he took me with him. It never seemed to occur to him that there could be any danger.

Visvanath was indeed an expert *shikāri*. He knew that there was nothing manly about hunting from a *māchān*. He would call the tiger out and shoot face to face, and he never missed his aim.

The jungle was dense, and in its lights and shadows the tiger refused to show himself. A rough kind of ladder was made by cutting footholds in a stout bamboo, and Jyotidada climbed up with his gun ready to hand. As for me, I was not even wearing slippers, I had not even that poor instrument with which to beat and humiliate the tiger. Visvanath signed to us to be on the alert, but for some time Jyotidada could not even see the tiger. After long straining of his bespectacled eyes he at last caught a glimpse of one

of its markings in the thicket. He fired. By a lucky chance the shot pierced the animal's backbone, and it was unable to rise. It roared furiously, biting at all the sticks and twigs within reach, and lashing its tail. Thinking it over, I know that it is not in the nature of tigers to wait so long and patiently to be killed. I wonder if some one had had the forethought to mix a little opium with its feed on the previous night? Otherwise, why such sound sleep?

There was another occasion when a tiger came to the jungles of Shelidah. My brother and I set out on elephants to look for him. My elephant lurched majestically on, uprooting cane from the sugar-cane fields and munching as he went, so that it was like riding on an earthquake. The jungle lay ahead of us. He crushed the trees with his knees, pulled them up with his trunk and cast them to the ground. I had previously heard tales of terrible possibilities from Visvanath's brother Chamru, how sometimes the tiger leaps on to the elephant's back and clings there, digging in his claws. Then the elephant trumpeting with pain, rushes madly through the forest, and whoever is on his back is dashed against the trees till arms, legs and head are crushed out of all recognition. That day, as I sat my elephant, the image of myself thus being pounded to a jelly filled my imagination from first to last. For very shame I concealed my fear, and glanced from side to side in nonchalant fashion, as though to say, "Let me but catch a glimpse of the tiger, and

then!..." The elephant entered the densest part of the jungle, and coming to a certain place, suddenly stood stock-still. The *māhout* made no attempt to urge it forward. He had clearly more respect for the tiger's powers as a *shikāri* than for my brother's. His great anxiety was undoubtedly that Jyotidada should so wound the tiger as to drive it to desperation. Suddenly the tiger leaped from the jungle, swift as the thunder-charged storm from the cloud. We are accustomed to the sight of a cat, dog, or jackal, but here were shoulders of terrific bulk and power, yet no sense of heaviness in that perfectly proportioned strength. It crossed the open fields at a canter in the full blaze of the midday sun. What loveliness, ease and speed of motion! The land was empty of crops; here indeed was a setting in which to feast one's eyes on the running tiger, this wide stretch of golden stubble drenched in the noonday sunlight.

There is one more story that may prove amusing. In Shelidah the gardener used to pluck flowers and arrange them in the vases. I took a fancy to write poetry with a pen dipped in the coloured essences of flowers. But the moisture that I could obtain by squeezing was not sufficient to wet the tip of my pen. I decided that it must be done by machinery. It would do, I thought, if I had a cup-shaped wooden sieve and a pestle revolving in it. It could be turned by an arrangement of ropes and pulleys. I made known my wants to Jyotidada. It may be that he smiled to himself,

but he gave no outward sign. He issued instructions, and the carpenter brought wood. The machine was ready. I filled the wooden cup with flowers, but turn the ropes of the pestle as I would the flowers, merely turned to mud and not a drop of essence ran out. Jyotidada saw that the essence of flowers was incompatible with the grinding of machinery, yet he never laughed at me.

This was the only occasion in my life on which I tried my hand at engineering. It is said in the *sāstras* that there is a god who compasses the humiliation of those who ignore their own limitations. That god cast a mocking glance that day upon my engineering, and from that time I have not so much as laid hands on any kind of instrument, not even on a *sitār* or an *esrāj*.

I described in my *Reminiscences* how Jyotidada went bankrupt in his attempt to run a *swadeshi* steamer company on the rivers of Bengal in competition with the Flotilla Company. *Bouthākrun's* death had taken place before then. Jyotidada gave up his rooms on the third storey and finally built himself a house on a hill at Ranchi.

XII

A new chapter in the life of the third storey room now opened, as I took up my abode there. Up to that time it had been merely one of my gypsy haunts, like the palanquin and the granary, and I roamed from one to another. But when *Bouthākrun* came a garden appeared on the roof, and in the room a piano was established. Its flow of new tunes symbolised the changed tenor of my life.

Jyotidada used to arrange to have his coffee in the mornings in the shade of the staircase room on the eastern side of the terrace. At such times he would read to us the first draft of some new play of his. From time to time I also would be called upon to add a few lines with my unpractised hand. The sun's rays gradually invaded the shade, the crows cried hoarsely to each other as they sat on the roof keeping an eye upon the bread-crumbs. By ten o'clock the patch of shade had dwindled away and the terrace grew hot.

At midday Jyotidada used to go down to the office on the ground floor. *Bouthākrun* peeled and cut fruit and arranged it carefully on a silver plate, along with a few sweetmeats made with her own hands, and strewed a few rose petals over it. In a tumbler was coconut milk or fruit-juice or *tāl shāns* (fresh palmyra kernels), cooled in ice. Then she covered it with a silk kerchief embroidered with flowers, put it on a Moradabad tray, and despatched it to the office at tiffin time, about one or two o'clock.

Just then *Bangadarsan*[1] was at the height of its fame, and *Suryamukhi* and *Kundanandini*[2] were familiar figures in every house. The whole country thought of nothing else but what had happened and what was gong to happen to the heroines.

When *Bangadarsan* came there was no midday nap for anyone in the neighbourhood. It was my good fortune not to have to snatch for it, for I had the gift of being an acceptable reader. *Bouthākrun* would rather listen to my reading aloud than read for herself. There were no electric fans then, but as I read I shared the benefits of *Bouthākrun's* hand fan.

1. A famous Bengali magazine edited by the well-known Bengali novelist, Bankim Chandra Chatterji.
2. Characters in Bankim Chandra's novel.

XIII

Now and again Jyotidada used to go for change of air to a garden house on the bank of the Ganges. The Ganges shores had then not yet lost caste at the defiling touch of English commerce. Both shores alike were still the undisturbed haunt of birds, and the mechanised dragons of industry did not darken the light of heaven with the black breath of their upreared snouts.

My earliest memory of our life by the Ganges is of a small two-storey house. The first rains had just fallen. Cloud shadows danced on the ripples of the stream, cloud shadows lay dark upon the jungles of the further shore. I had often composed songs of my own on such days, but that day I did not do so. The lines of Vidyapati came to my mind, *e bharā bādara māha bhādara śūnya mandira mōr.*[1] Moulding them

1. Brimmed with rain is the month of Bhadra (August-September), empty my spirit's dwelling stands.

to my own melody and stamping them with my own musical mood, I made them my own. The memory of that monsoon day, jewelled with that music on the Ganges shore, is still preserved in my treasury of rainy season songs. I see in memory the tree-tops struck ever and again by great gusts of wind, till their boughs and branches were tangled together in an ecstasy of play. The boats and dinghies raised their white sails and scudded before the gale, the waves leaped against the *ghāt* with sharp, slapping sounds. *Bouthākrun* came back and I sang my song to her. She listened in silence and said no word of praise. I must then have been sixteen or seventeen years old. We used to have arguments even then about various matters, but no longer in the old spirit of childish wrangling.

A little while after we removed to Moran's Garden. That was a regular palace. The rooms, of varying heights, had coloured glass in their windows, the floors were of marble, and steps led down from the long verandah to the very edge of the Ganges. Here a fit of wakefulness by night came upon me, and I used to pace to and fro, as I did later on the banks of the Sabarmati. That Garden is no longer in existence, the iron jaws of the Dundee Mills have crushed and swallowed it.

At the mention of Moran's Garden there comes back the memory of our occasional picnics under the *bakul* tree. The food owed its flavour not to spices but to the hands that prepared it. How I remember

our sacred-thread ceremony, when we two boys were fed by *Bouthākrun* with the ceremonial rice and fresh ghee! For those three days we had our fill of tasty and savoury dishes.

It was a great annoyance to me that it was so difficult for me to fall ill. All the other boys in the house could manage it, and then they would enjoy *Bouthākrun's* personal care. Not only did they enjoy her care, but they took up all her time, and my own share of it was correspondingly diminished.

So came to an end that page of the history of the third storey, and with it *Bouthākrun* also passed away. After that the second floor became my own domain, but it was no longer as in the old days.

I have wandered in my story up to the very gateway of my young manhood. I must return to the territory of my boyhood once more.

Now I must give some account of my sixteenth year. At its very entrance stands *Bhārati*.[2] Nowadays the whole country seethes with the excitement of bringing out papers, and I can well understand the strength of that passion when I look back on my own madcap escapades. That a boy like me, with neither learning nor talents, should succeed in establishing

2. Monthly magazine founded by Jyotidada (Jyotirindranath Tagore) and first edited by the Poet's eldest brother Dwijendranath Tagore, referred to here as Baḍadada. It ran for about half a century.

himself in that *salon,* or at least in escaping reprimand there, shows what a youthful spirit was abroad everywhere. *Bangadarśan* was then the only magazine in the country controlled by a mature hand. As for ours, it was a medley of the mature and the crude. Baḍadada's contributions were as difficult to understand as they were to write; and side by side with them stood a story of mine, the raw verbosity of whose style I was too young to appraise, nor did others apparently possess the critical judgment to do so.

The time has come to say something of Baḍadada. Jyotidada held court in that third storey room, and Baḍadada in our south verandah. At one time he plunged into the deepest problems of metaphysics, far outside the range of our comprehension. There were few to listen to what he wrote and thought, and he would not lightly let any man go who showed himself willing to be audience. Nor would the man himself soon relinquish Baḍadada, but what he claimed from him was not alone the privilege of listening to metaphysics. One such man attached himself whose name I do not remember, but everyone called him "The Philosopher". My other brothers made great fun of him, not only about his love for mutton chops, but about his endless stream of varied and urgent necessities. Besides philosophy, Baḍadada then began to take great interest in the construction of mathematical problems. The verandah would be full of papers, covered with figures, flying about in the

south wind. Baḍadada could not sing, but he used to play an English flute, not for the sake of the music, but in order to measure mathematically the notes of each scale. After that he occupied himself for a time in writing *Svapna-Prayāna*. To start with, he began to experiment in verse-making, weighing the sound-values of Sanskrit words in the scales of Bengali rhythm, and so creating new forms. Many of these attempts he retained, but many he threw away, and torn pages were scattered everywhere. After that he started to write his book of poems, but he rejected far more than he kept, for he was not easily satisfied with his work. We had not the sense to pick up and keep all these discarded lines. As he wrote he would read his work, and people would gather round him to listen. Our whole household was intoxicated with this wine of poetry. Sometimes in the midst of his reading he would burst into a great shout of laughter. His laughter was ample and generous as the skies, but woe betide the man who sat within reach when the fit took him; he received slaps on the back to shake his very soul. The south verandah was the living fountain of the life of Jorasanko, but the fountain dried up when Baḍadada went to live at the Santiniketan *asrama*. I remember, however, times spent in the garden opposite that south verandah, when with mind made listless by the touch of the autumn sun I composed and sang a new song: "Today in the autumn sun, in my dreams of dawn, a nameless yearning fills my soul." I remember also a

song made in the quivering heat of one blazing noon: "In this listless abandon of spirit, I know not what games I kept on playing with my own self."

Another striking thing about Baḍadada was his swimming. He would swim backwards and forwards across our tank at least fifty times. When he lived at Panihati Garden he used to swim far out into the Ganges. With his example before us we also learned to swim as boys. We started to learn by ourselves. We would wet our pyjamas and then pull them up tight so as to fill them with air. In the water they swelled out round our waists like balloons, and we could not possibly sink. When I was older and stayed on the river-lands[3] of Shelidah, I once swam across the Padma. This was not as wonderful an achievement as it sounds. The Padma was full of alluvial islands which broke the force of its current, so that the feat was not worthy of any great respect. Still, it was certainly a story with which to impress others, and I have used it so many times. When I went as a boy to Dalhousie, my father never forbade me to wander about by myself. With an alpenstock in my hand I traversed the footpaths, climbing one hill after another. It was most amusing to scare myself with my own make-believe. Once while going steeply downhill I stepped on a heap of withered leaves at the foot of a tree. My foot slipped

3. Tracts of rich alluvial land often found as islands in the great rivers (Beng. *Char*).

a little and I saved myself with my stick. But perhaps I might not have been able to stop myself! I wondered how long it would have taken to roll down the steep slope and fall into the waterfall far below. I described to Mother with picturesque inventiveness all that might have happened. Then, wandering in the deep pinewoods, I might suddenly have come upon a bear that also was certainly something worth talking about. As nothing ever really happened I stored up all these imaginary adventures in my mind. The story of my swimming across the Padma was much of a piece with this class of romances.

When I was seventeen I had to leave the editorial board of *Bhārati,* for it was then decided that I should go to England. Further it was considered that before sailing I should live with *Mejadādā*[4] for a time to get some grounding in English manners. He was then a judge in Ahmedabad, and *Meja-Bouthākrun* and her children were in England, waiting for *Mejadādā* to get a furlough and join them.

I was torn up by the roots and transplanted from one soil to another, and had to get acclimatised to a new mental atmosphere. At first my shyness was a stumbling-block at every turn. I wondered how I should keep my self-respect among all these new acquaintances. It was not easy to habituate myself to strange surroundings, yet there was no means of escape

4. Second brother, Satyendranath Tagore.

from them; in such a situation a boy of my temperament was bound to find his path a rough one.

My fancy, free to wander, conjured up pictures of the history of Ahmedabad in the Moghul period. The judge's quarters were in Shahibag, the former palace grounds of the Muslim kings. During the daytime *Mejadādā* was away at his work, the vast house seemed one cavernous emptiness, and I wandered about all day like one possessed. In front was a wide terrace, which commanded a view of the Sabarmati river, whose knee-deep waters meandered along through the sands. I felt as though the stone-built tanks, scattered here and there along the terrace, held locked in their masonry wonderful secrets of the luxurious bathing-halls of the Begums.

We are Calcutta people, and history nowhere gives us any evidence of its past grandeur there. Our vision had been confined to the narrow boundaries of these stunted times. In Ahmedabad I felt for the first time that history had paused, and was standing with her face turned towards the aristocratic past. Her former days were buried in the earth like the treasure of the *yakshas.*[5] My mind received the first suggestion for the story of *Hungry Stones.*

How many hundred years have passed since those times! Then in the *nahabat-khānā*, the minstrel's gallery, an orchestra played day and night, choosing

5. Demons who guard treasure.

tunes appropriate to the eight periods of the day. The rhythmic beat of horses' hoofs echoed on the streets, and great parades were held of the mounted Turkish cavalry, the sun glittering on the points of their spears. In the court of the Pādshāh whispered conspiracies were ominously rife. Abyssinian eunuchs, with drawn swords, kept guard in the inner apartments. Rose-water fountains played in the *hamāms* of the Begums, the bangles tinkled on their arms. Today Shahibag stands silent, like a forgotten tale; all its colour has faded, and its varied sounds have died away; the splendours of the day are withered and the nights have lost their savour.

Only the bare skeleton of those old days remained, its head a naked skull whose crown was gone. It was like a mummy in a museum, but it would be too much to say that my mind was able fully to re-clothe those dry bones with flesh and blood and restore the original form. Both the first rough model, and the background against which it stood, were largely a creation of the fancy. Such patch-work is easy when little is known and the rest has been forgotten. After these eighty years even the picture of myself that comes before me does not correspond line for line with the reality, but is largely a product of the imagination.

After I had stayed there for some time *Mejadādā* decided that perhaps I should be less homesick if I could mix with women who could familiarise me with conditions abroad. It would also be an easy way to

learn English. So for a while I lived with a Bombay family. One of the daughters of the house was a modern educated girl who had just returned with all the polish of a visit to England. My own attainments were only ordinary, and she could not have been blamed if she had ignored me. But she did not do so. Not having any store of book-learning to offer her, I took the first opportunity to tell her that I could write poetry. This was the only capital I had with which to gain attention. When I told her of my poetical gift, she did not receive it in any carping or dubious spirit, but accepted it without question.. She asked the poet to give her a special name, and I chose one for her which she thought very beautiful. I wanted that name to be entwined with the music of my verse, and I enshrined it in a poem which I made for her. She listened as I sang it in the *Bhairavi* mode of early dawn, and then said, "Poet, I think that even if I were on my death-bed your songs would call me back to life." There is an example of how well girls know how to show their appreciation by some pleasant exaggeration. They simply do it for the pleasure of pleasing. I remember that it was from her that I first heard praise of my personal appearance,—praise that was often very delicately given.

For example, she asked me once very particularly to remember one thing: "You must never wear a beard. Don't let anything hide the outline of your face." Everyone knows that I have not followed that

advice. But she herself did not live to see my disobediene proclaimed upon my face.

In some years, birds strange to Calcutta used to come and build in that banyan tree of ours. They would be off again almost before I had learnt to recognize the dance of their wings, but they brought with them a strangely lovely music from their distant jungle homes. So, in the course of our life's journey, some angel from a strange and unexpected quarter may cross our path, speaking the language of our own soul, and enlarging the boundaries of the heart's possessions. She comes unbidden, and when at last we call for her she is no longer there. But as she goes, she leaves on the drab web of our lives a border of embroidered flowers, and for ever and ever the night and day are for us enriched.

XIV

The Master-Workman, who made me, fashioned his first model from the native clay of Bengal. I have described this first model, which is what I call my boyhood, and in it there is little admixture of other elements. Most of its ingredients were gathered from within, though the atmosphere of the home and the home people counted for something too. Very often the work of moulding goes no further than this stage. Some people get hammered into shape in the book-learning factories, and these are considered in the market to be goods of a superior stamp.

It was my fortune to escape almost entirely the impress of these mills of learning. The masters and pundits who were charged with my education soon abandoned the thankless task. There was Jnanachandra Bhattacharya, the son of Anandachandra Vedāntabāgish, who was a B.A. He realised that this boy could never be driven along the beaten tract of learning. The teachers of those days, alas! were not so strongly convinced that

boys should all be poured into the mould of degree-holding respectability. There was then no demand that rich and poor alike should all be confined within the fenced-off regions of college studies. Our family had no wealth then, but it had a reputation, so the old traditions held good, and they were indifferent to conventional academic success. From the lower classes of the Normal School we were transferred to De Cruz's Bengal Academy. It was the hope of my guardians that even if I got nothing else, I should get enough mastery of spoken English to save my face. In the Latin class I was deaf and dumb, and my exercise books of all kinds kept from beginning to end the unrelieved whiteness of a widow's cloth. Confronted by such unprecedented determination not to study, my class-teacher complained to Mr. De Cruz, who explained that we were not born for study, but for the purpose of paying our monthly fees. Jnana Babu was of a similar opinion, but found means of keeping me occupied nevertheless. He gave me the whole of *Kumārsambhava*[1] to learn by heart. He shut me in a room and gave me *Macbeth* to translate. Then Pundit Ramsarbaswa read *Sakuntalā* with me. By setting me free in this way from the fixed curriculum, they reaped some reward for their labours. These then were the materials that formed my boyish mind, together with what other Bengali books I picked up at random.

1. A work of Kalidasa.

I landed in England, and foreign workmanship began to play a part in the fashioning of my life. The result is what is known in chemistry as a compound. How capricious is Fortune!—I went to England for a regular course of study, and a desultory start was made, but it came to nothing. *Meja-Bouthān* was there, and her children, and my own family circle absorbed nearly all my interest. I hung about around the school-room, a master taught me at the house, but I did not give my mind to it.

However, gradually the atmosphere of England made its impression on my mind, and what little I brought back from that country was from the people I came in contact with. Mr. Palit finally succeeded in getting me away from my own family. I went to live with a doctor's family, where they made me forget that I was in a foreign land. Mrs. Scott lavished on me a genuine affection, and cared for me like a mother. I had then been admitted to London University, and Henry Morley was teaching English literature. His teaching was no dry-as-dust exposition of dead books. Literature came to life in his mind and in the sound of his voice, it reached to our inner being where the soul seeks its nourishment, and nothing of its essential nature was lost. With his guidance, I found the study of the Clarendon Press books at home to be an easy matter and I took upon myself to be my own teacher. For no reason at all Mrs. Scott would sometimes fancy that I did not look well, and would become very

worried about me. She did not know that the portals of sickness had been barred against me from childhood. I used to bathe every morning in ice-cold water—in fact, in the opinion of the doctors, it was almost a sacrilege that I should survive such flagrant disregard of the accepted rules!

I was able to study in the University for three months only, but I obtained almost all my understanding of English culture from personal contacts. The Artist who fashions us takes every opportunity to mingle new elements in his creation. Three months of close intimacy with English hearts sufficed for this development. Mrs. Scott made it my duty each evening till eleven o'clock to read aloud from poetic drama and history by turn. In this way I did a great deal of reading in a short space of time. It was not prescribed class study, and my understanding of human nature developed side by side with my knowledge of literature. I went to England but I did not become a barrister. I received no shock calculated to shatter the original framework of my life—rather East and West met in friendship in my own person. Thus it has been given me to realise in my own life the meaning of my name.[2]

2. The poet's name *Rabi* means the sun, which does not distinguish between East and West.